Genesis One Creation Story

By

Deana G. Harvey, Artist

The story of creation is in Technicolor…

Copyright © 2014 Deana G. Harvey

All Rights Reserved

ISBN – 13:9781492172857

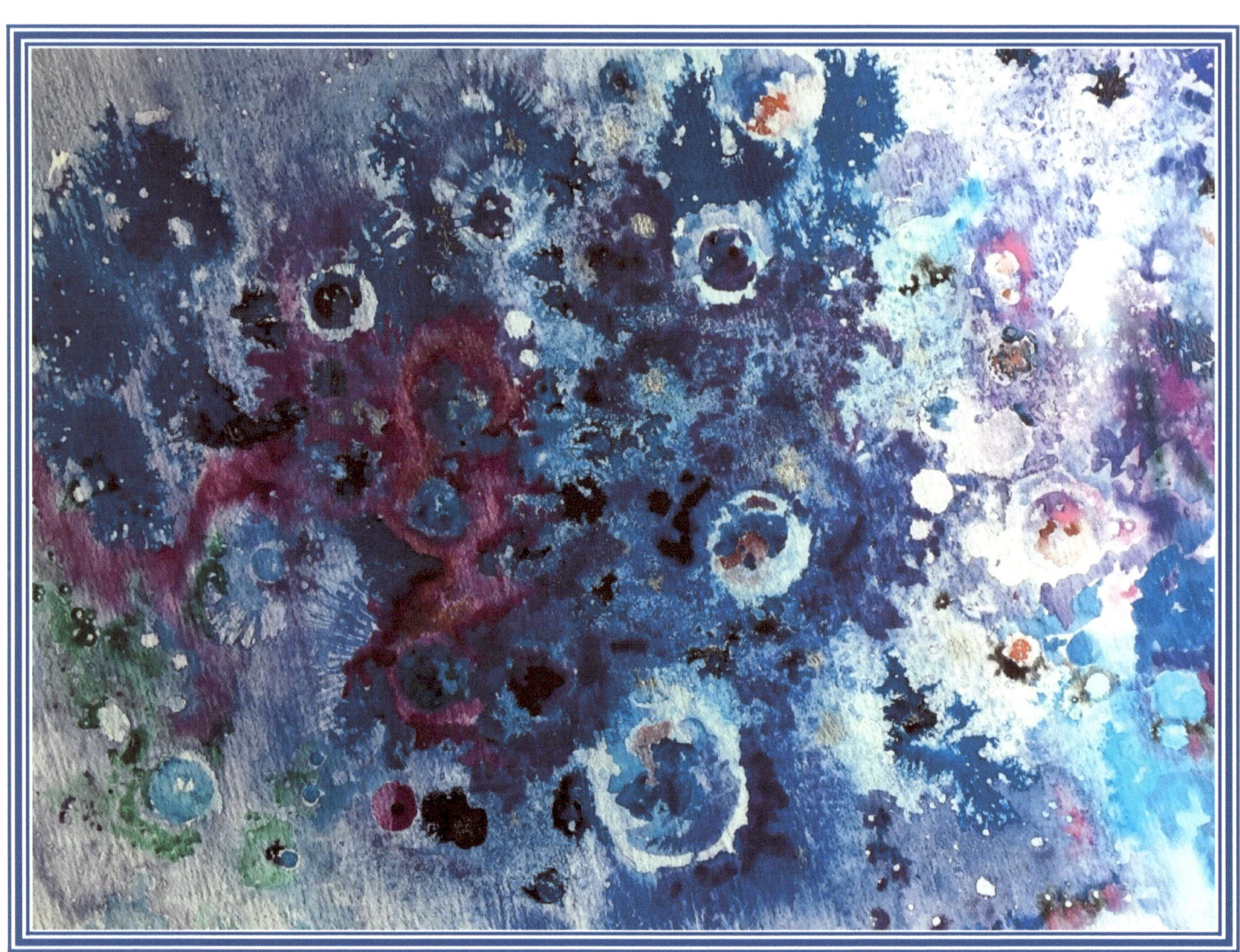

In the beginning God created the heavens and the earth.

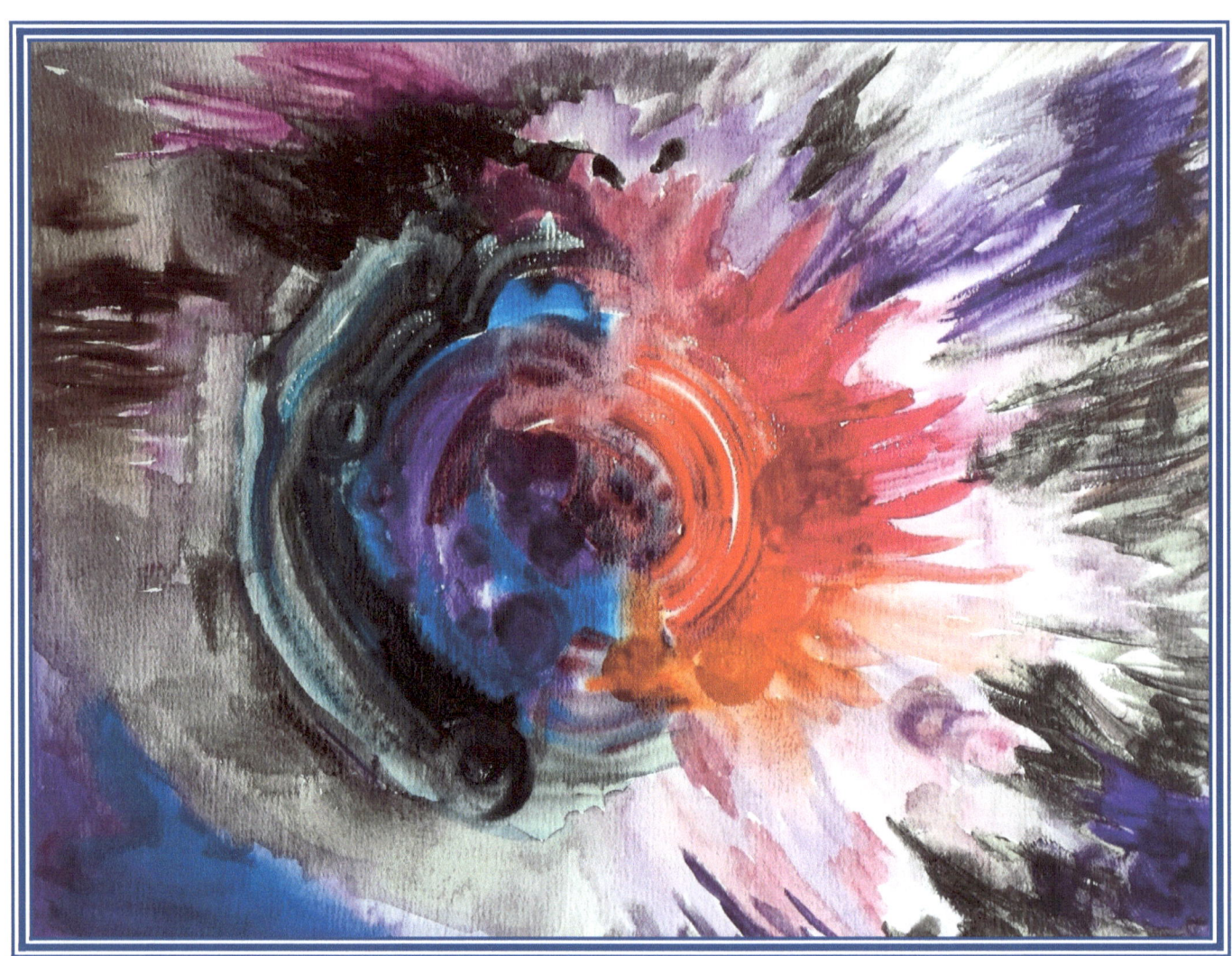

And the earth was without shape and without life. There was deep, darkness everywhere.

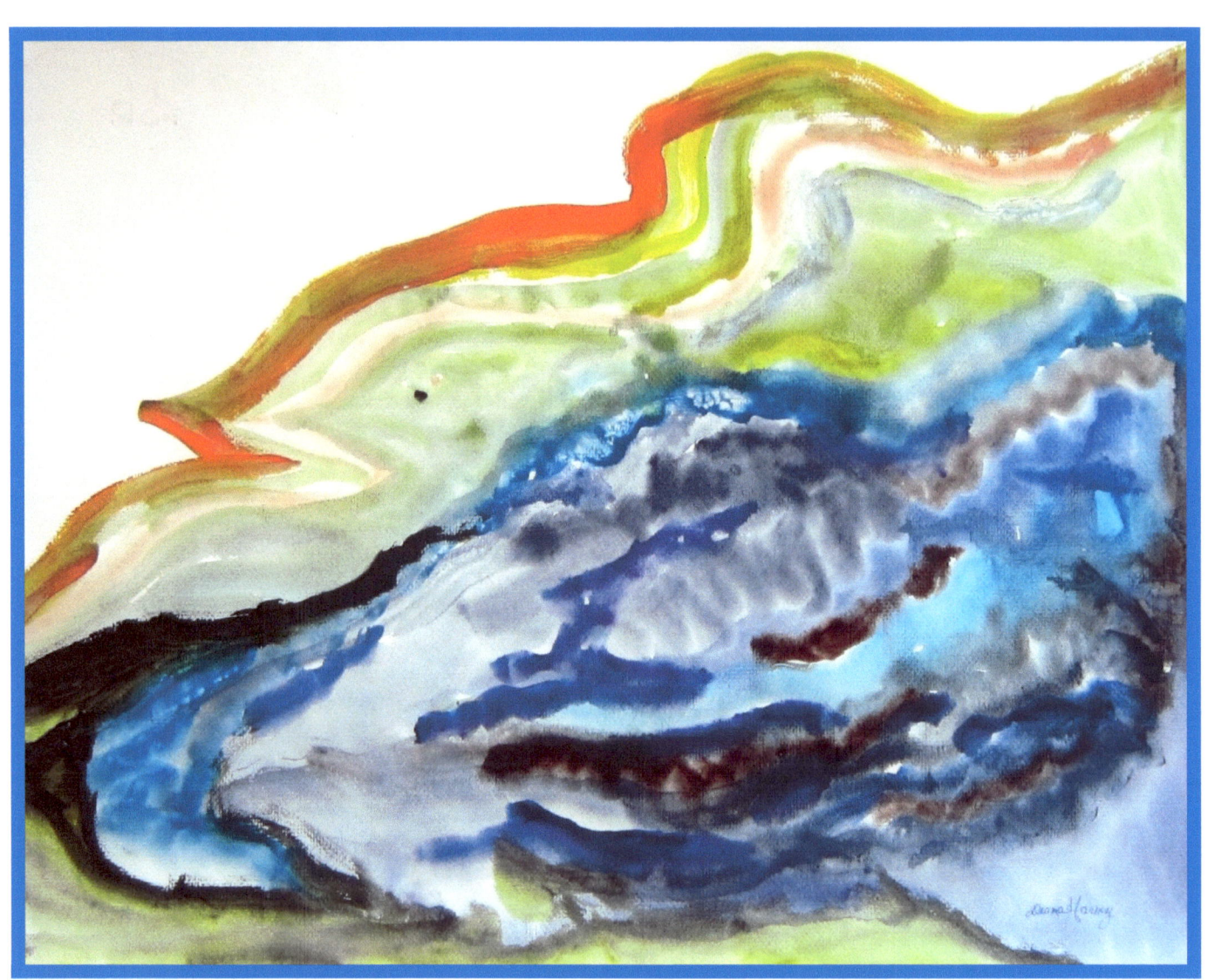

But the Spirit of God moved over the face of the deep, black darkness. Aren't you glad you and I didn't have to try living there in nothingness—all alone in the dark?

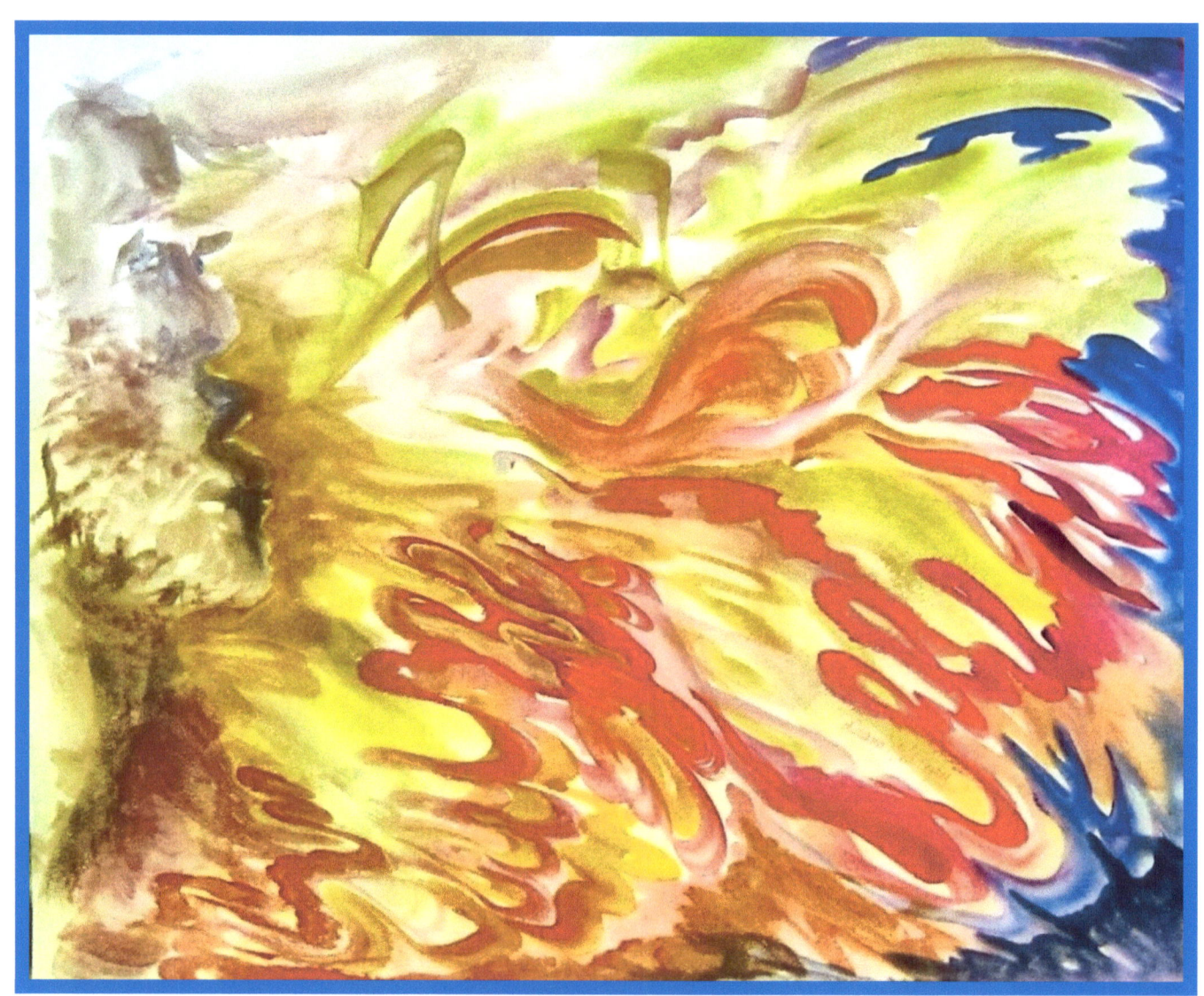

And then God said, "Let there be light!" and there was light!

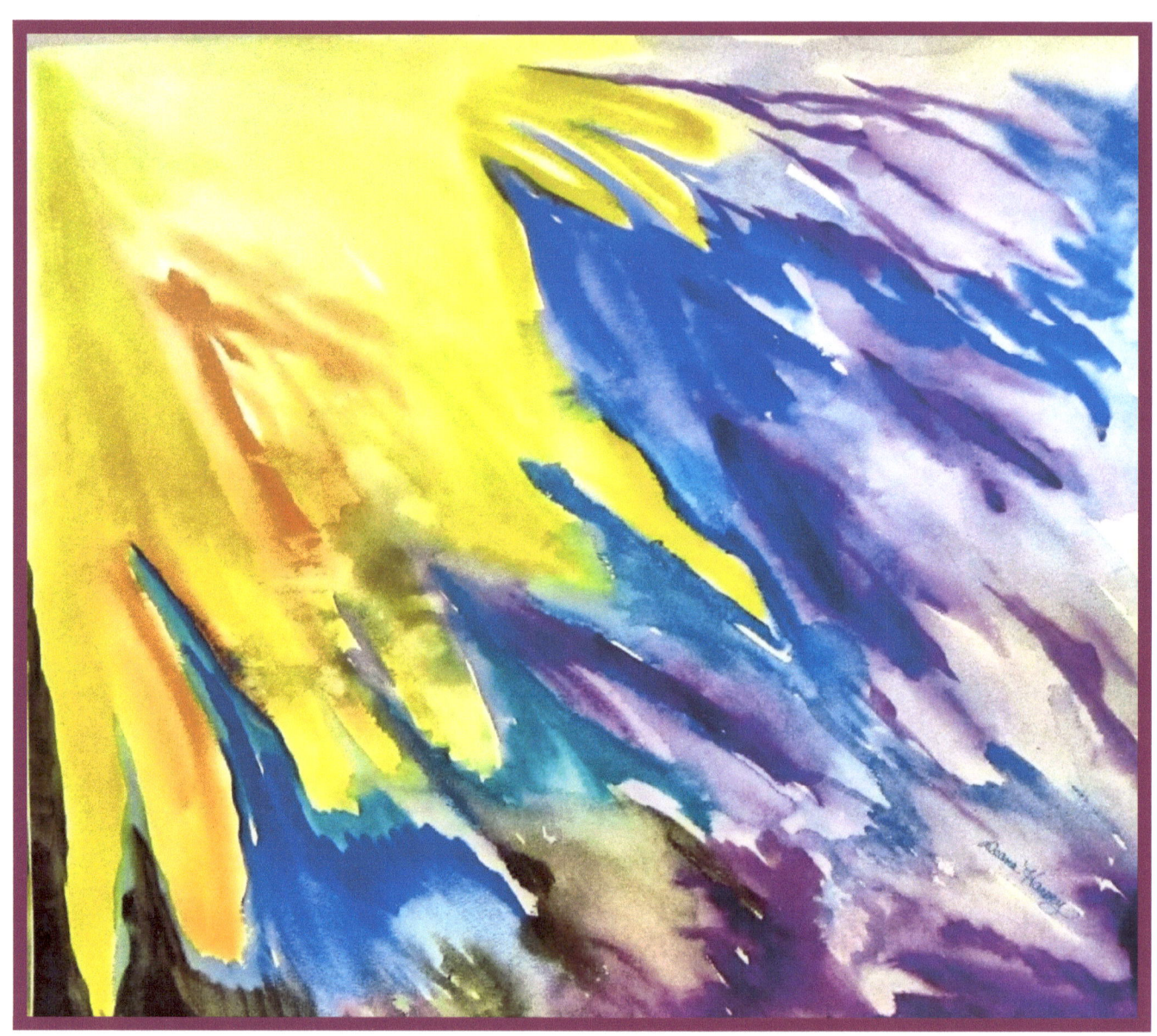

And God saw that the light was good, so God divided the light from the darkness. So God called the light DAY and the darkness NIGHT. It was the first morning and the first evening in history. It was the FIRST day.

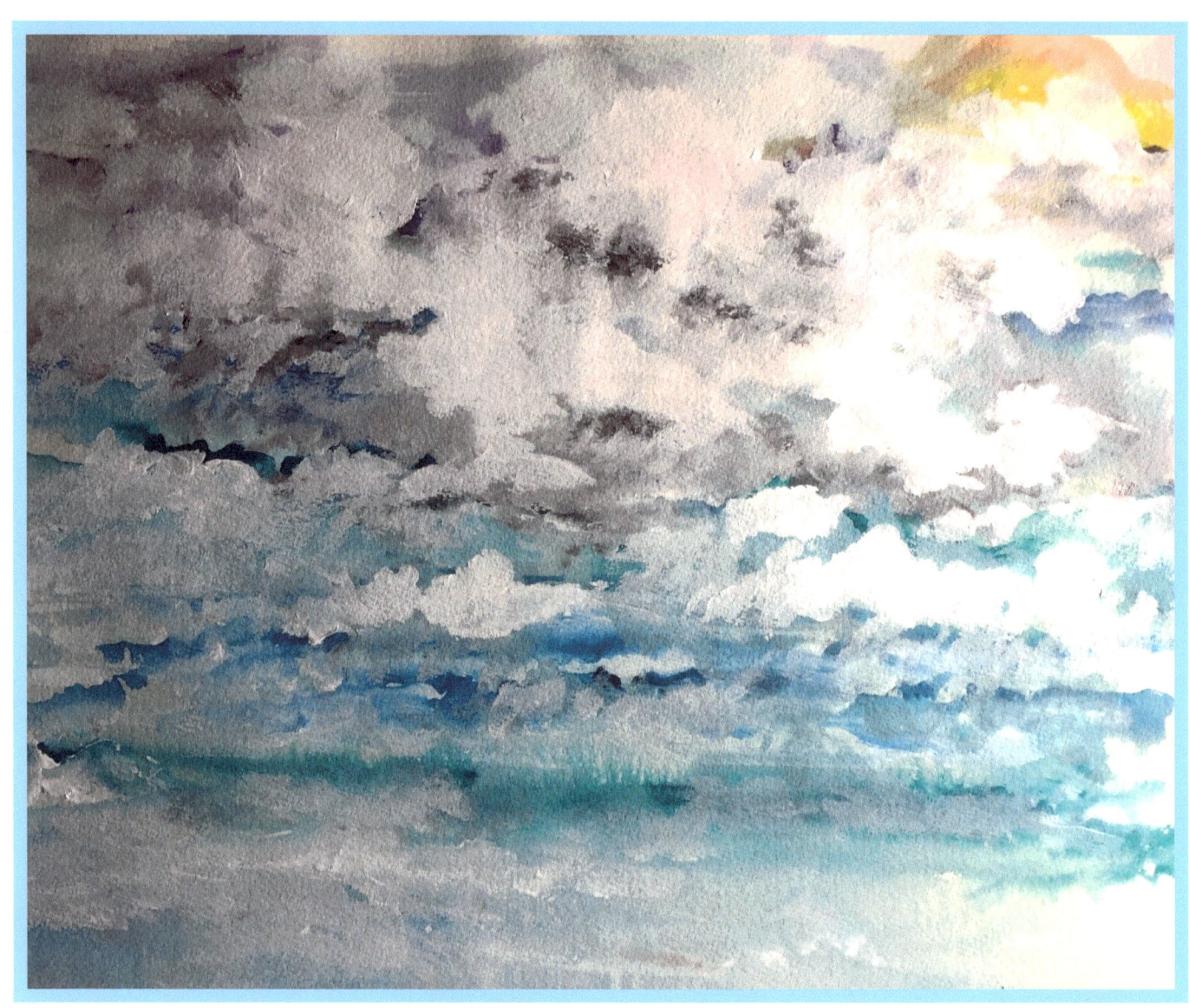

And then God said, "Let there be a sky like heaven so it can divide the bottom of the universe from the top." And so it was, and God called the upper portion HEAVEN. He did all that on the evening and the morning of the SECOND day.

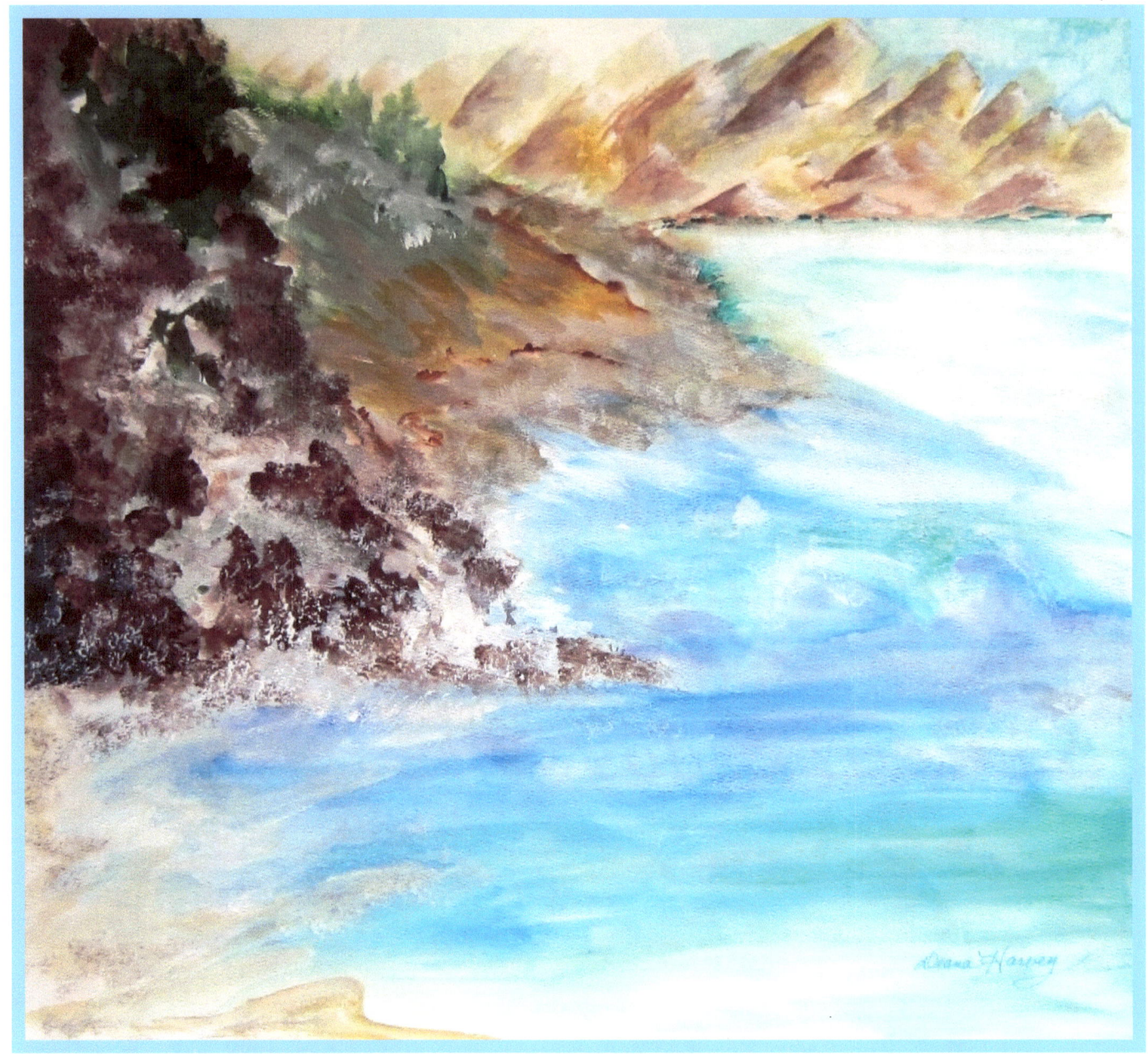

Next, under the heavens, God gathered all the waters together into one place. And out of the deep waters, dry land appeared. He called the dry land EARTH; and all the waters He called SEAS. When God saw it, He said it was good.

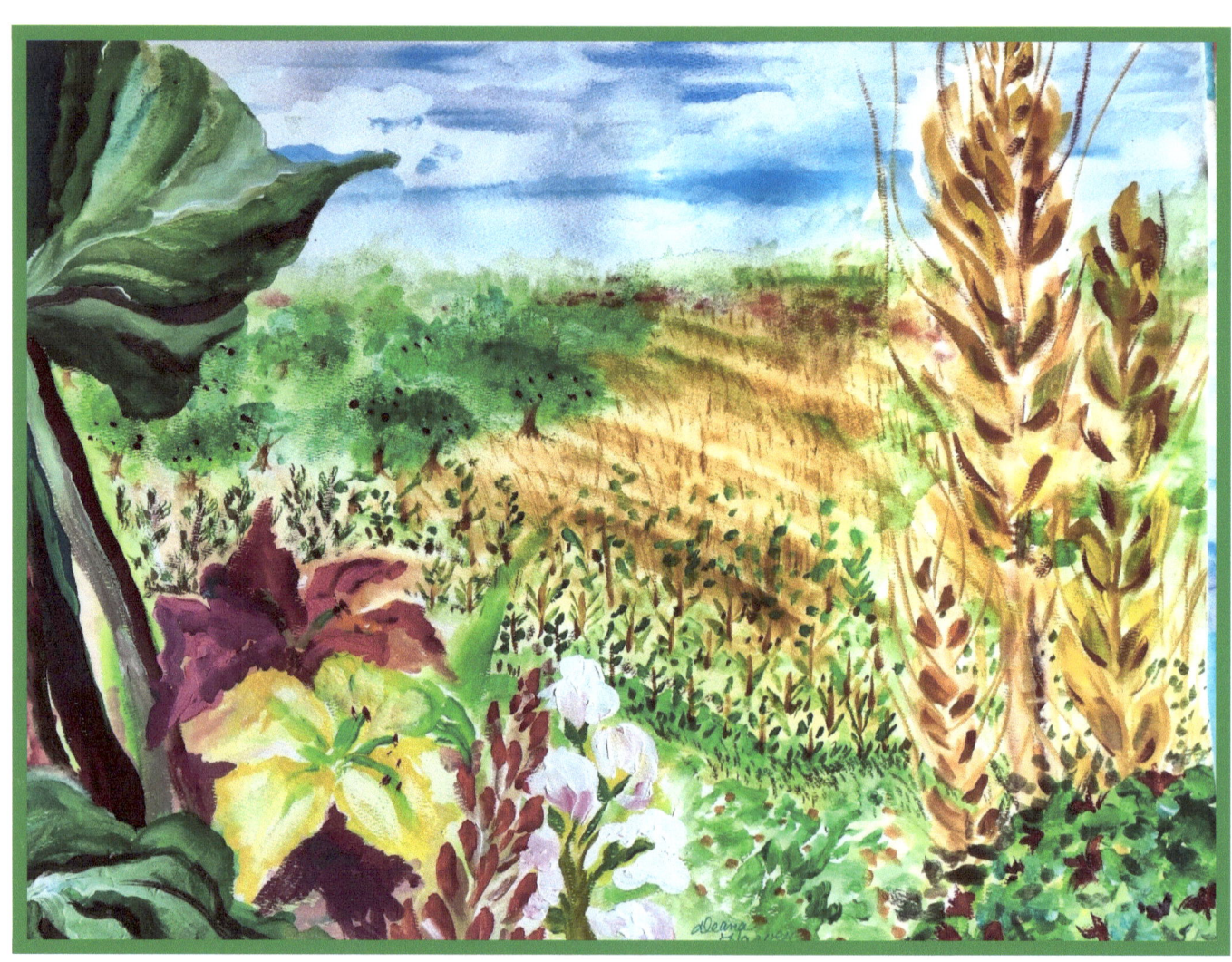

Then God said, "Let the earth grow grass and seeds, fruit trees and everything that grows." God saw that it was good. I can see that it is very beautiful. How about you?

It was now the THIRD day in history. WOW the earth was only three days old.

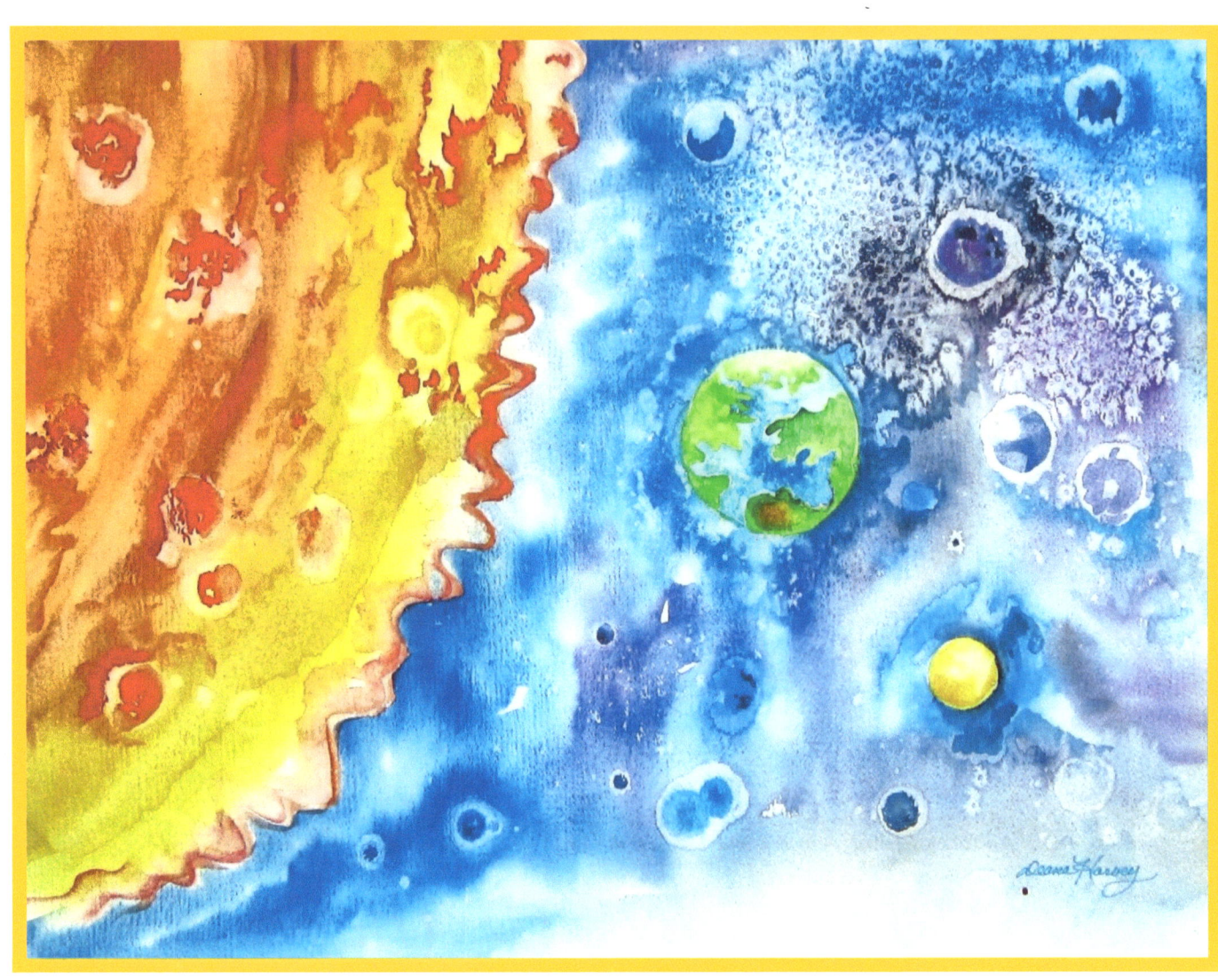

In the heavens, God made lights for day and night. He made them so they would light up the earth. He made the sun for day time and the moon and stars for night time. Everything is good the way God makes it.

That was day FOUR.

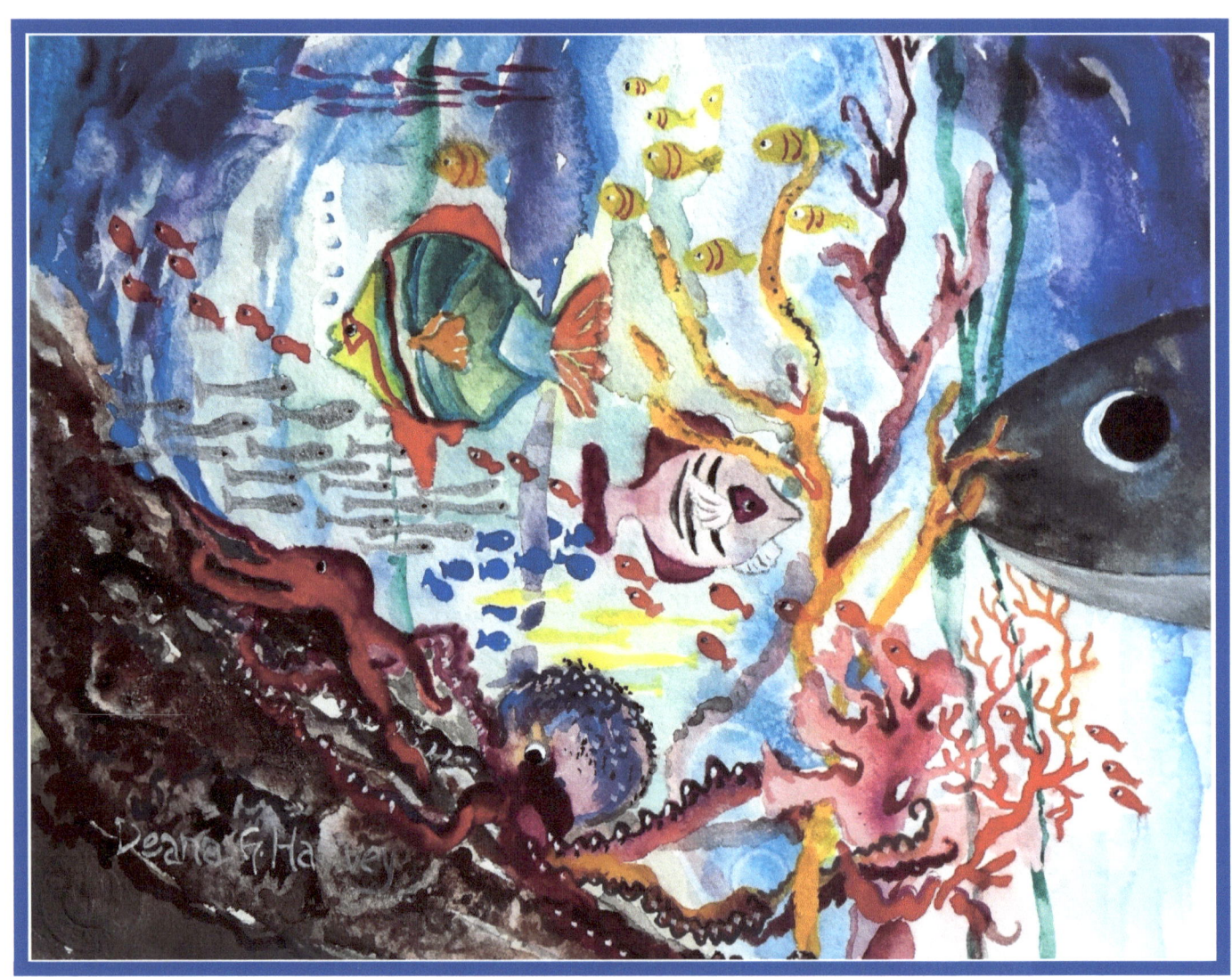

Then God said, "Let us make the fish in the sea. Big ones, small ones, turquoise and yellow striped ones, along with starfish, octopus, whales and sharks. Coral reefs are filled with the beauty of God's imagination. You have a good imagination too.

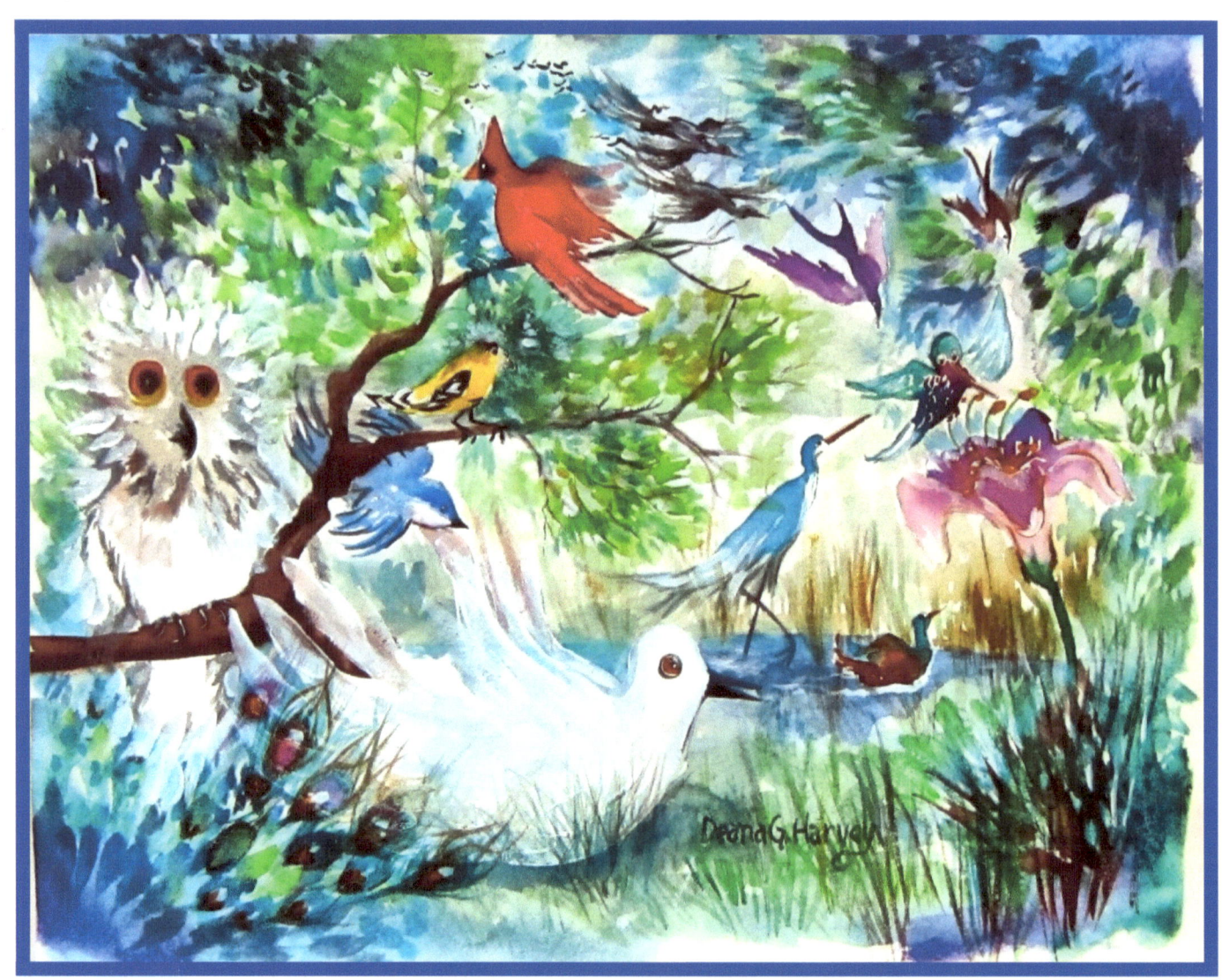

"Let us make birds in the sky", God said. He made blue birds, cardinals, finches, snowy owls, humming birds, egrets, ducks and so many kinds of flying creatures.

All the birds sing praise to God, how about you? Do you sing songs to God?

And that was day FIVE.

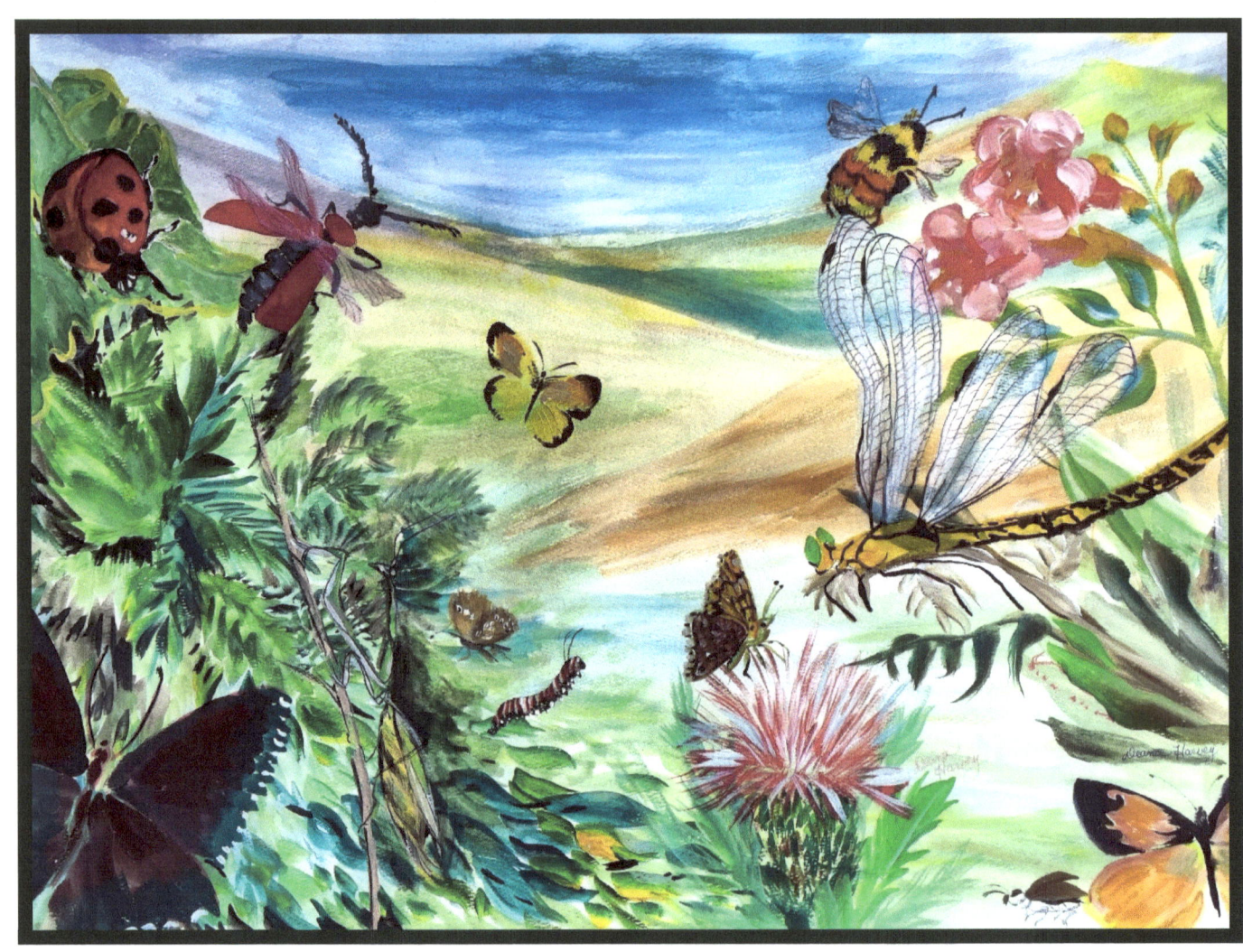

God said, "Let us make all of the insects that crawl and fly on the earth." He made butterflies, bumble bees, praying mantis, caterpillars, red cardinal beetles and all of them multiplied across the earth. All of God's creation becomes many and more and more in number...so many you can't even count all the stars, trees, fish, and birds.

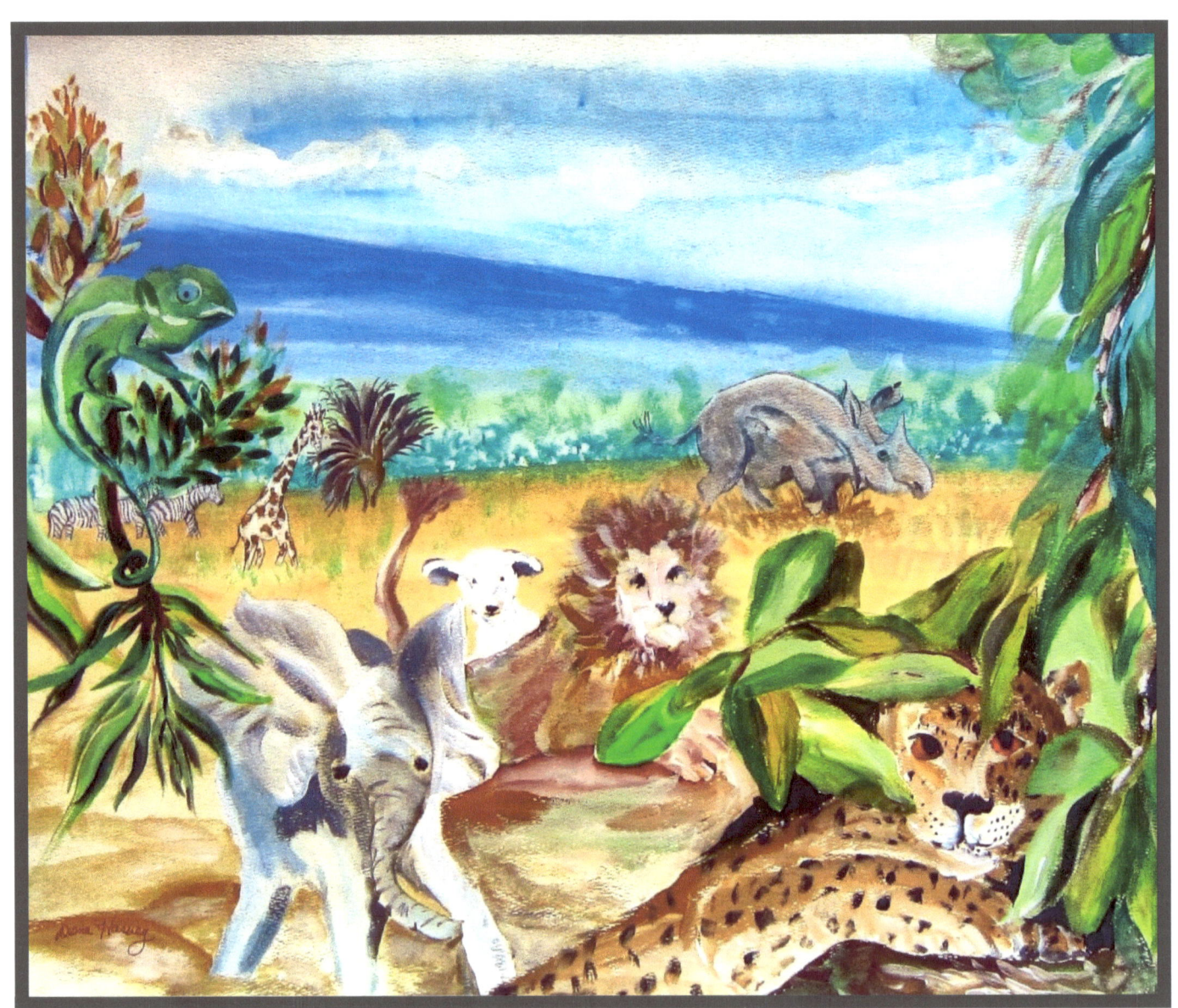

On day SIX, God said, "Let us make cattle and every kind of animal." So He created cattle, lions, bears, lambs, chameleons, leopards and everything that walks on the earth. And they all multiplied and became many. All that God made multiplied across the earth. And God said, "It is good" to all His creation.

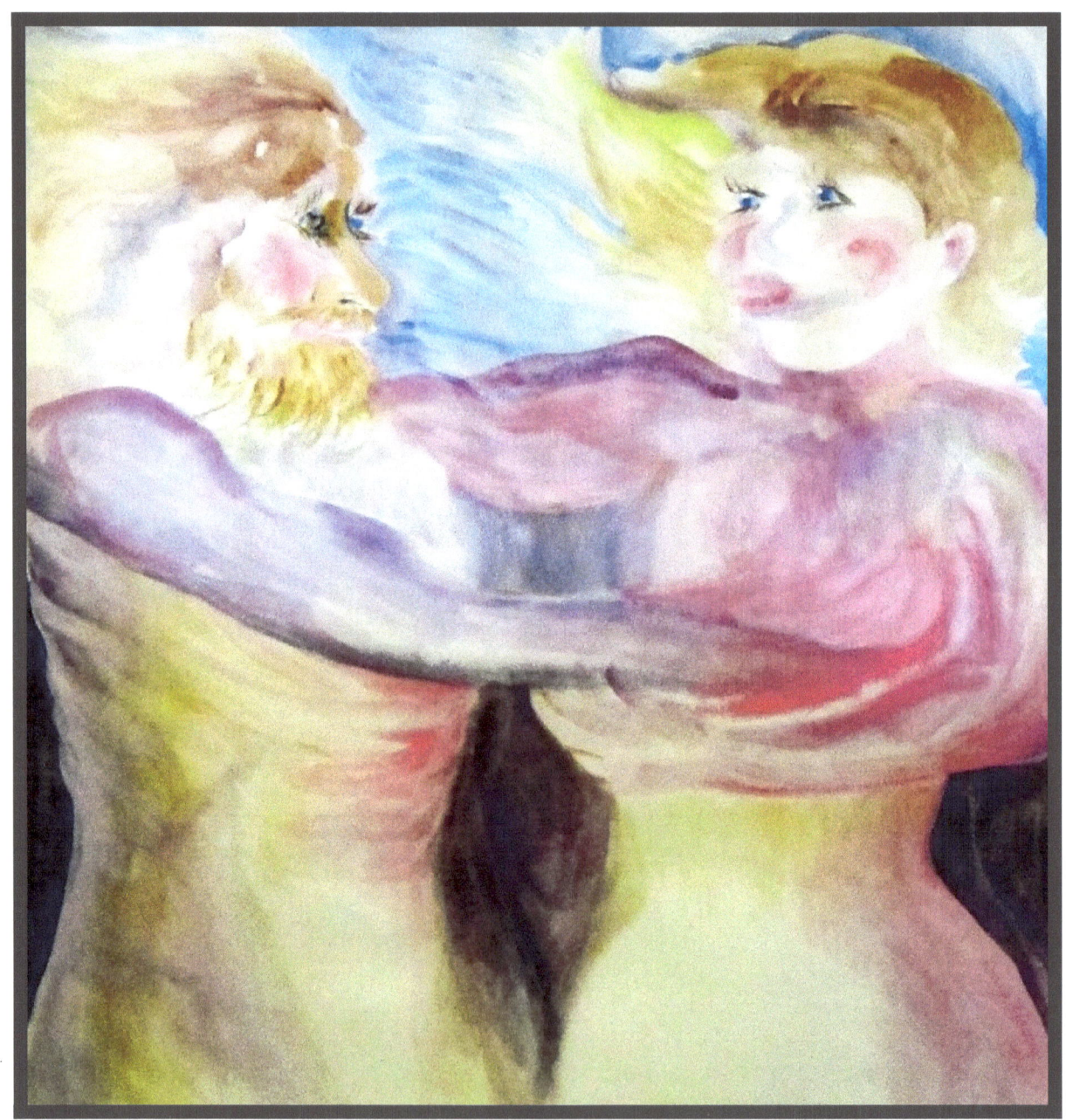

The most special creation was you. God spoke and said, "Let us make man and woman in our very own image. Let us bless them and give them glory and honor with authority over all we have created." And they multiplied over the earth, reflecting God's image everywhere.

Do you think you could count all the people on the Earth today? We can't but God can. God can talk to everybody. He created you for a personal relationship with the Godhead. He enjoys you.

God sees everything and says, "It is very good!" So, you see, God thinks you are very good and very special, and He loves you very much-- everlastingly. His love lasts forever.

On day SEVEN God rested from all of His labor. He did not fall asleep because God never sleeps. Instead, He enjoyed and partied with creation, singing songs over it. You can rest with God because it is finished. You can party with God, because He is happy with you. Aren't you glad!

Draw a picture of you.

THE END

AUTHOR CONTACT INFORMATION

Deana G. Harvey, Author-Artist lives in Roanoke, IN with her husband and mini pin named Mickey Mouse. Deana is passionate about God, God's Word and Art. She does art about the prophetic/spiritual world and art about the natural world. Deana worked at LHN Hospital of Indiana for 16 ½ years doing art therapy activities with Alzheimer's patients and also with addictions patients. Deana shares an art gallery with Vintage Glory Clothing Store owned by Emily Shilts, located in Roanoke, IN 260-402-7951. The Tree of Life Art Gallery houses Deana's art and the art of other local, award winning artists. "I love being surrounded by God's beauty and art everyday of my life. The view is breathtaking!."

Other books written by Deana G Harvey are: The Tree of Life, Peetie the Peacock, Sea Turtle Life, and, The Lord's Prayer—Amplified. All these titles showcase the artist's original art. To purchase these titles you may contact the artist at 260-402-7951.

Face Book: Deana Harvey and Deana Tree of Life Art Gallery Roanoke, IN
Instagram: deana_tree_of_life
Website: Deana Artist for God @ wix.com